NIGHT LIGHTS & PILLOW FIGHTS™
GENIUS CLUB
LET'S DRAW CARTOONS!

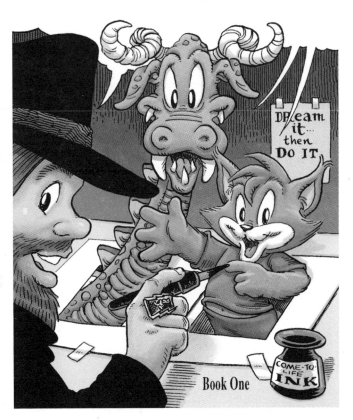

Book One

Night Lights & Pillow Fights
Comics featuring Mudpie
Book One

Night Lights & Pillow Fights,
Mudpie and Mudpie character names
are trademarks of Guy Gilchrist.

Gilchrist Features
P.O. Box 1194
Canton, CT 06019

A Gilchrist Publishing Book
Published by Gilchrist Publishing, P.O. Box 1194
Canton, CT 06019

Library of Congress Catalog Card Number: 9660473-6-2
First GP Printing: November 1999
ISBN: 0-9660473 6-2

Printed in Singapore

To Jayme and Carly,
who love to draw.

A Message to Readers from Guy-

I'm so glad you're drawing with me today! Be creative and follow your heart and you'll do well!

In this book we are reprinting some of your favorite drawing lessons and games from my Night Lights and Pillow Fights newspaper feature.

In some comic panels you will see us mention that you can send in your drawings to be printed. That offer was made to our newspaper readers when it was first printed in the paper so this does not mean we will print your art in any future books! But feel free to send in drawings in hopes of appearing sometime in the comic strip! Okay? Okay.

Keep on Dreaming ... and Doing.

God Bless you,
Guy

REMEMBER---- YOU ARE **CHEERED** IN THE SPOT- LIGHT...

I LOVE 2 DRAW!

IT'S FUN!

.... THE **MORE** YOU **PRACTICE** BACK- STAGE!

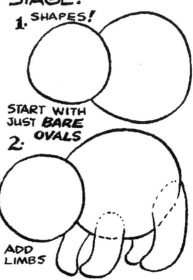

1. SHAPES!

START WITH JUST **BARE** OVALS

2.

ADD LIMBS

3. KEEP GOING

©1999

4. DONE! YOUR OWN *LIVE* TEDDY BEAR!

9/4

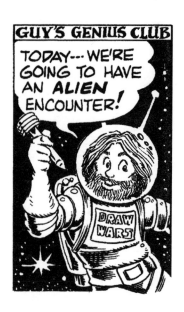

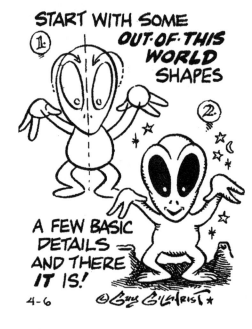

4-6

© Guy Gilchrist

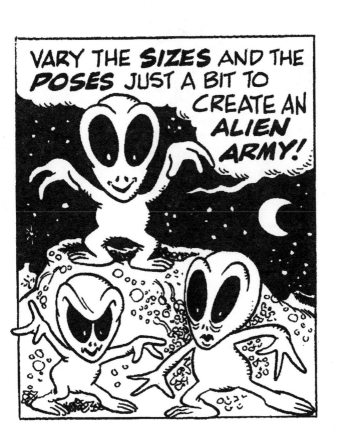

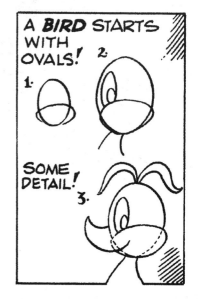

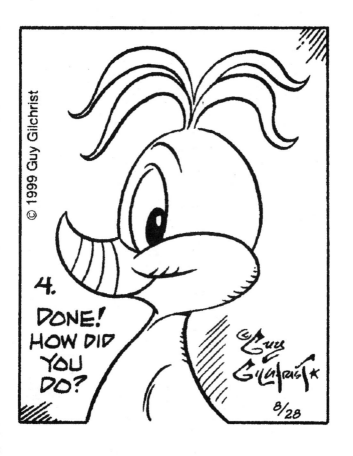

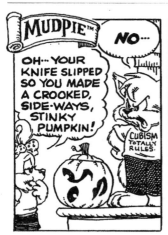

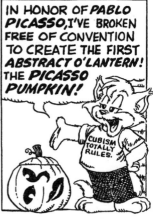

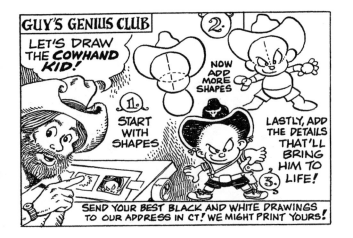

Practice Here

Which Two Pumpkins are the Same?

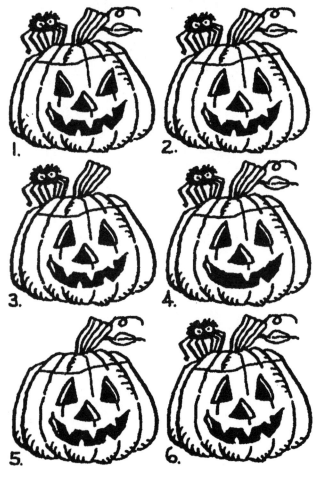

1.
2.
3.
4.
5.
6.

Pumpkins two and six are the same!

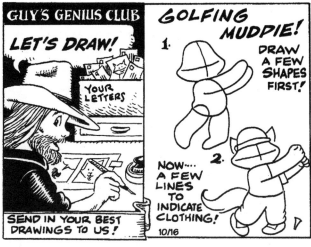

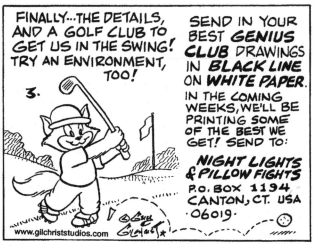

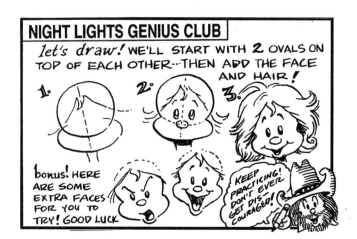

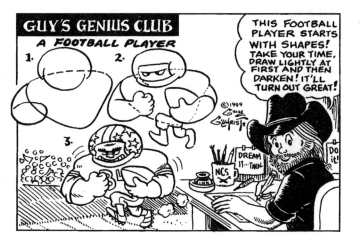

Practice Here

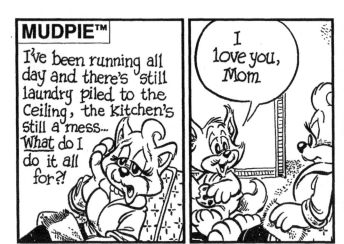

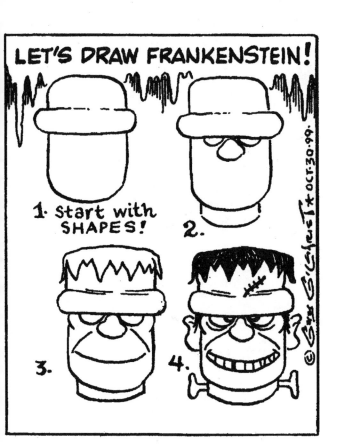

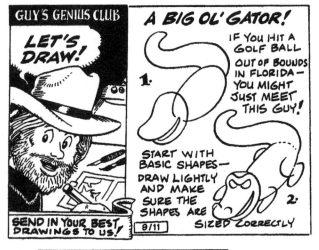

GUY'S GENIUS CLUB

LET'S DRAW!

SEND IN YOUR BEST, DRAWINGS TO US!

8/11

A BIG OL' GATOR!

1.

IF YOU HIT A GOLF BALL OUT OF BOUNDS IN FLORIDA — YOU MIGHT JUST MEET THIS GUY!

START WITH BASIC SHAPES — DRAW LIGHTLY AND MAKE SURE THE SHAPES ARE SIZED CORRECTLY

2.

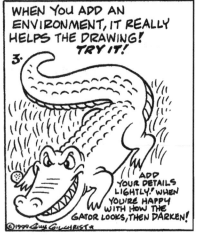

WHEN YOU ADD AN ENVIRONMENT, IT REALLY HELPS THE DRAWING! *TRY IT!*

3.

ADD YOUR DETAILS LIGHTLY! WHEN YOU'RE HAPPY WITH HOW THE GATOR LOOKS, THEN DARKEN!

©1999 Guy Gilchrist

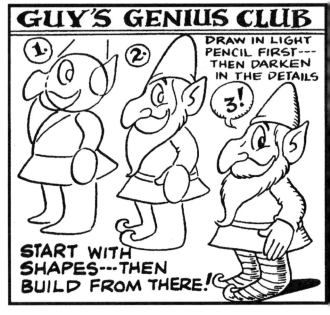

Practice Here

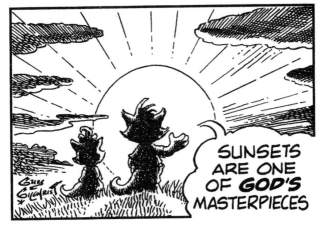

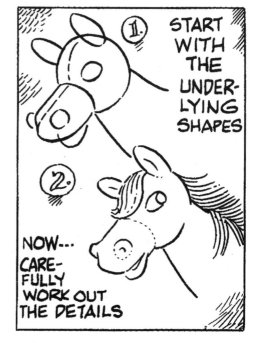

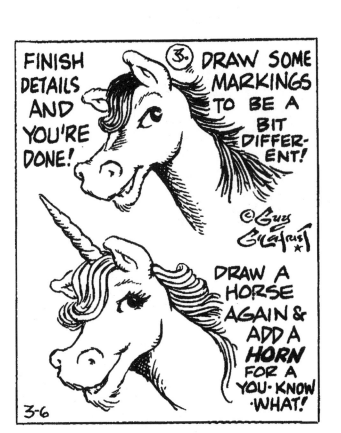

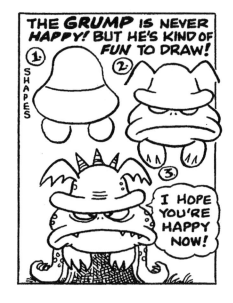

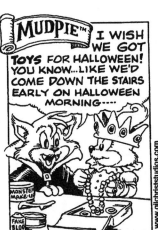

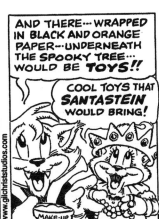

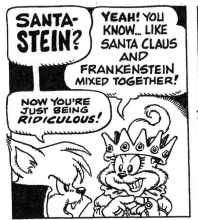

WHICH TWO FACES ARE THE SAME?

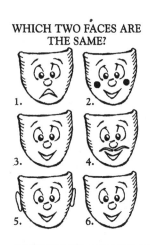

1.
2.
3.
4.
5.
6.

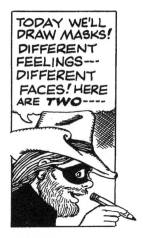

TODAY WE'LL DRAW MASKS! DIFFERENT FEELINGS--- DIFFERENT FACES! HERE ARE *TWO*----

Masks three and six are the same!

GUY'S GENIUS CLUB

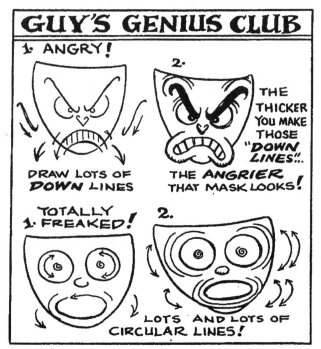

1. ANGRY!

DRAW LOTS OF *DOWN* LINES

2.

THE THICKER YOU MAKE THOSE *"DOWN LINES"*...

THE *ANGRIER* THAT MASK LOOKS!

TOTALLY 1. FREAKED!

2.

LOTS AND LOTS OF CIRCULAR LINES!

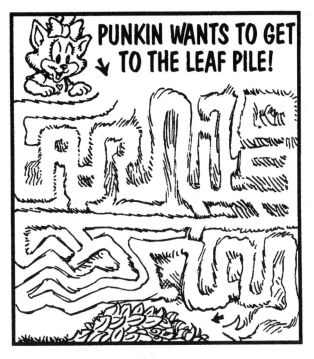

PUNKIN WANTS TO GET TO THE LEAF PILE!

WHICH TWO PILGRIMS ARE THE SAME?

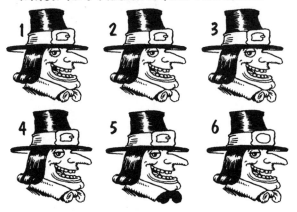

Pilgrims three and four are the same!

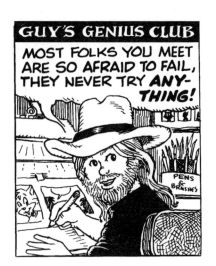

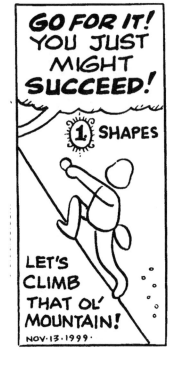

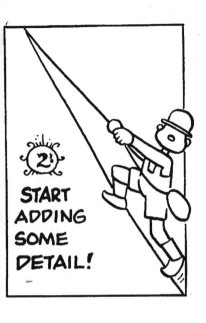

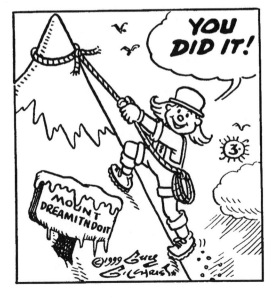

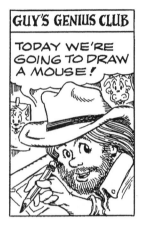

GUY'S GENIUS CLUB

TODAY WE'RE GOING TO DRAW A MOUSE!

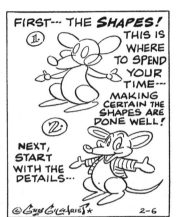

FIRST--- THE *SHAPES!*

1. THIS IS WHERE TO SPEND YOUR TIME--- MAKING CERTAIN THE SHAPES ARE DONE WELL!

2. NEXT, START WITH THE DETAILS...

© Guy Gilchrist

2-6

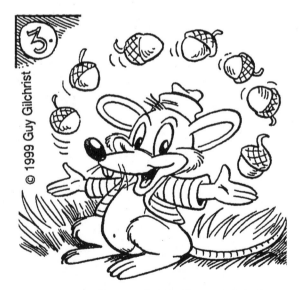

© 1999 Guy Gilchrist

IN THE END, THE CLOTHES, FUR, SOME "PROPS" AND AN ENVIRONMENT!

CONNECT THE DOTS TO FINISH OFF THIS "JOLLY ROGER"... THE PIRATE FLAG!

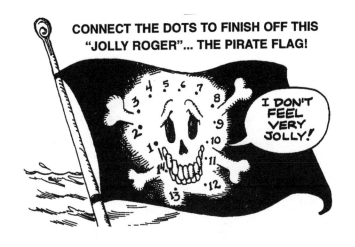

YO-HO-HO! WHICH TWO O' THESE DAGGER TOTIN', CROOKED OL' PIRATES ARE THE SAME, MATEY?

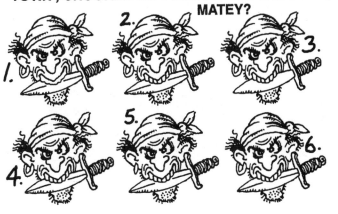

Pirates two and four are the same!

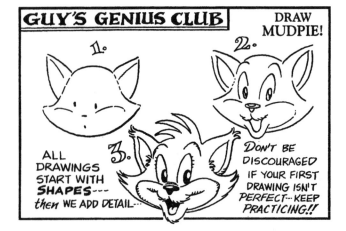

WHICH TWO PUNKINS ARE THE SAME?

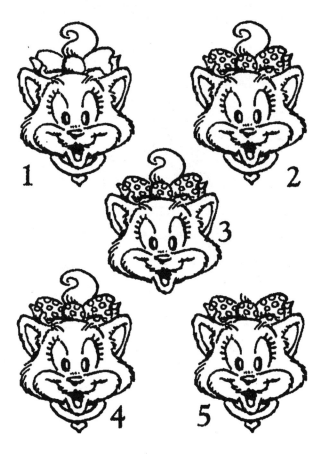

1

2

3

4

5

Punkins two and four are the same!

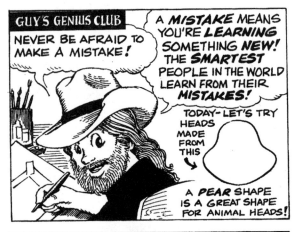

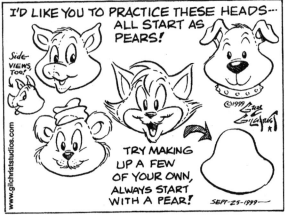

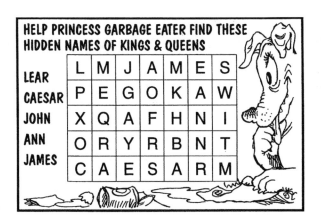

HELP PRINCESS GARBAGE EATER FIND THESE HIDDEN NAMES OF KINGS & QUEENS

LEAR
CAESAR
JOHN
ANN
JAMES

L	M	J	A	M	E	S
P	E	G	O	K	A	W
X	Q	A	F	H	N	I
O	R	Y	R	B	N	T
C	A	E	S	A	R	M

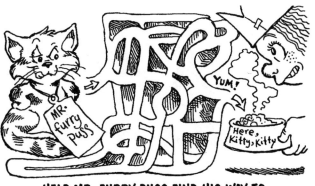

HELP MR. FURRY PUSS FIND HIS WAY TO HIS STINKY KITTY FOOD!

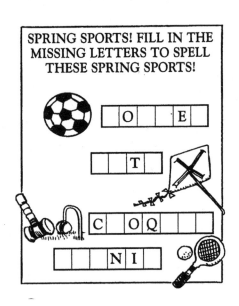

SPRING SPORTS! FILL IN THE MISSING LETTERS TO SPELL THESE SPRING SPORTS!

soccer, kite, croquet, tennis

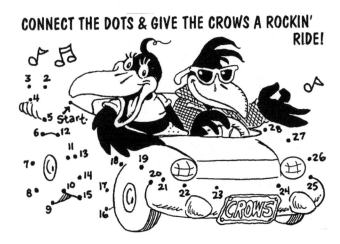

CONNECT THE DOTS & GIVE THE CROWS A ROCKIN' RIDE!

GUY'S GENIUS CLUB

TODAY'S DRAWING LESSON *QUACKS* ME *UP!*

DREAM IT... then DO IT!

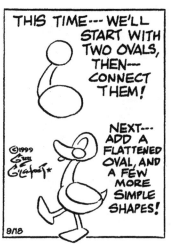

THIS TIME--- WE'LL START WITH TWO OVALS, THEN--- CONNECT THEM!

NEXT--- ADD A FLATTENED OVAL, AND A FEW MORE SIMPLE SHAPES!

©1999 Guy Gilchrist

8/18

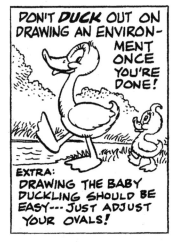

DON'T *DUCK* OUT ON DRAWING AN ENVIRON-MENT ONCE YOU'RE DONE!

EXTRA: DRAWING THE BABY DUCKLING SHOULD BE EASY--- JUST ADJUST YOUR OVALS!

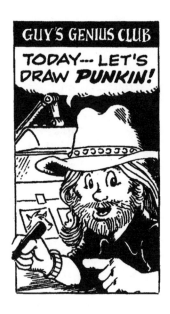

GUY'S GENIUS CLUB

TODAY--- LET'S DRAW *PUNKIN!*

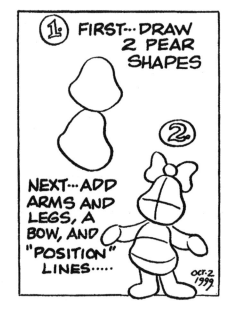

1. FIRST--- DRAW 2 PEAR SHAPES

2.

NEXT--- ADD ARMS AND LEGS, A BOW, AND "POSITION" LINES.....

OCT. 2 1999

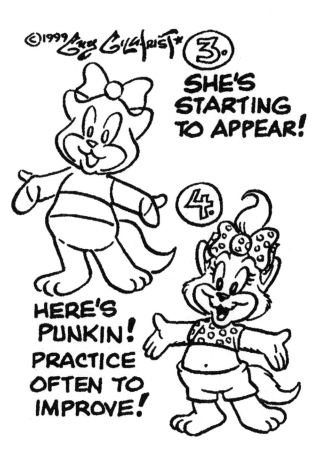

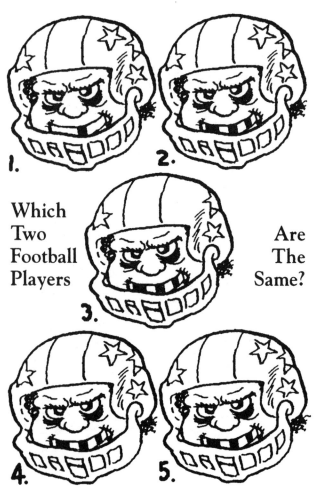

1.

2.

Which
Two
Football
Players

3.

Are
The
Same?

4.

5.

Numbers two and five are the same!

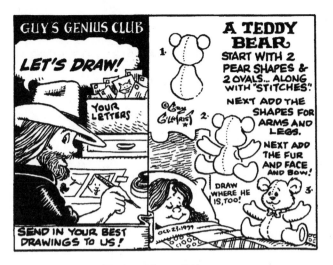

Practice Here

Which **2** bowler-wearing beagles are the same?

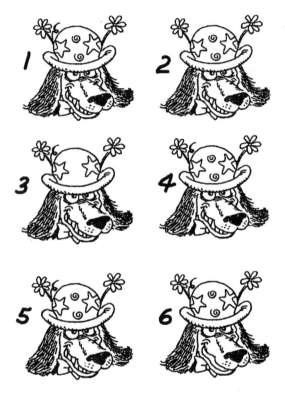

Beagles one and five are the same!

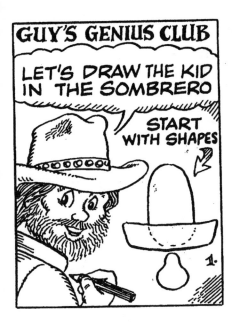

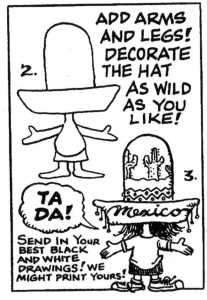

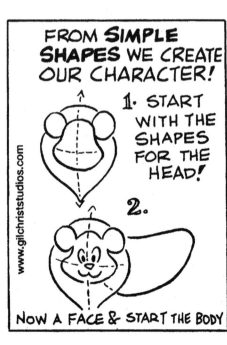

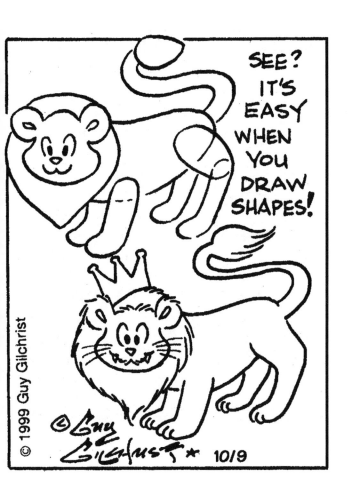

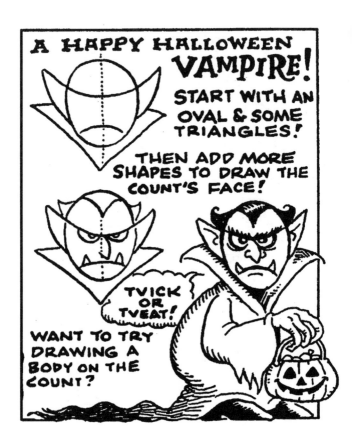

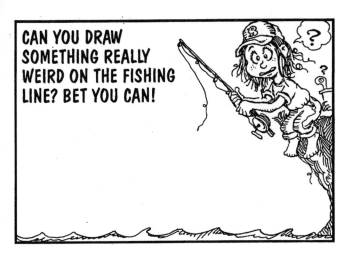

Practice Here

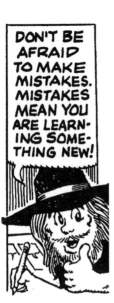

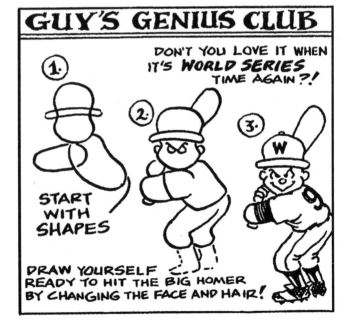

STRAWBERRY RHUBARB
LOVE SONG

Strawberry Rhubarb!
Sweet Potato Pie!
You're the apple sauce
Of my eye.
Jest as spicy!
Jest as sweet!
I love ya as much as
I love to eat!

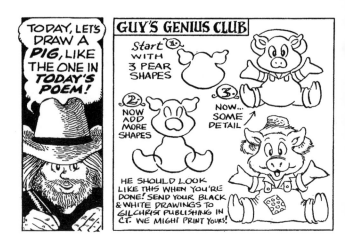

Practice Here

WHICH TWO PIGS ARE THE SAME?

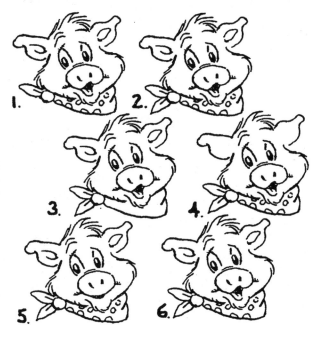

1.

2.

3.

4.

5.

6.

Pigs two and six are the same!

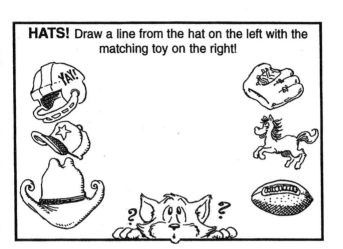

HATS! Draw a line from the hat on the left with the matching toy on the right!

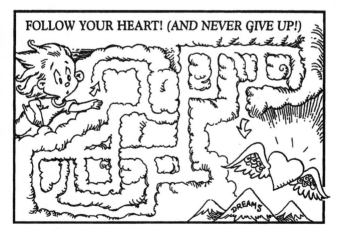

FOLLOW YOUR HEART! (AND NEVER GIVE UP!)

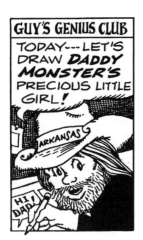

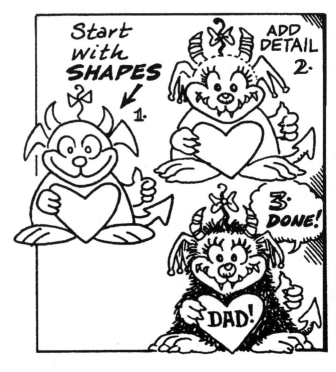

FIND THE TEN HIDDEN HEARTS!

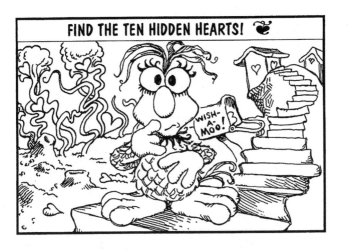

WHICH SHADOWS ARE THE SAME?

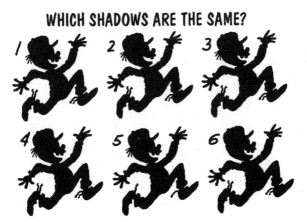

¡ǝɯɐs ǝɥʇ ǝɹɐ ǝǝɹɥʇ puɐ ǝuo sʍopɐɥS

Mom's Math... 133÷33=166; 3x3=9; 3x3x3=99 & 133+133+133=399!

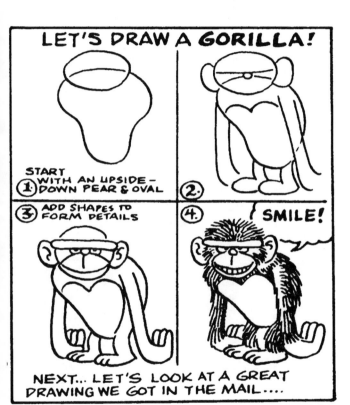

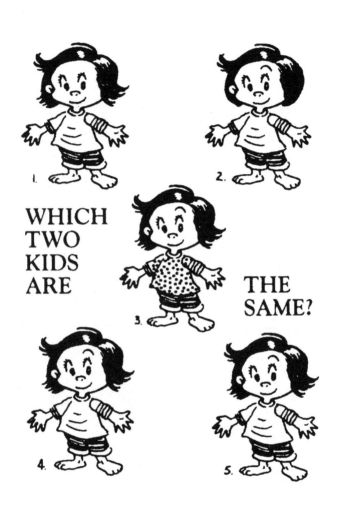

WHICH
TWO
KIDS
ARE

THE
SAME?

Kids four and five are the same!

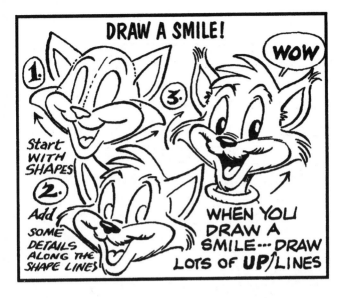

Practice Here

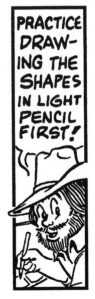

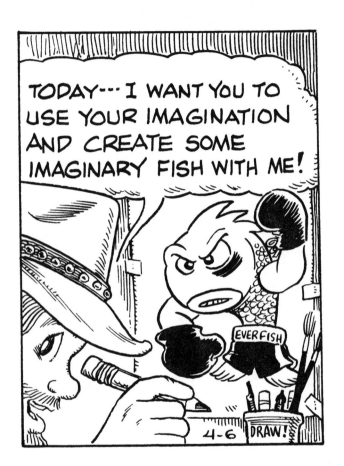

A FIGHTING FISH

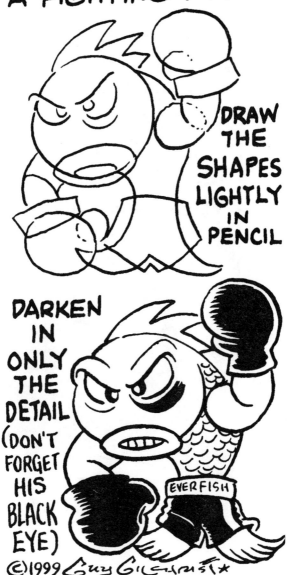

DRAW THE SHAPES LIGHTLY IN PENCIL

DARKEN IN ONLY THE DETAIL (DON'T FORGET HIS BLACK EYE)

EVERFISH

©1999 Guy Gilchrist

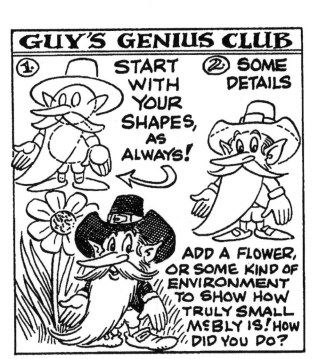

WHICH TWO GOLFING DADS ARE THE SAME?

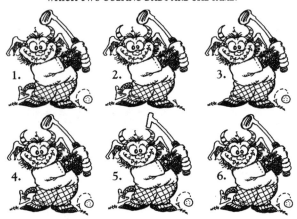

Golfers four and six are the same!

WHICH TWO SUMMER MONSTERS
ARE THE SAME?

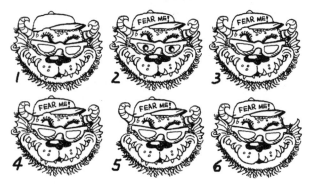

Monsters three and four are the same!

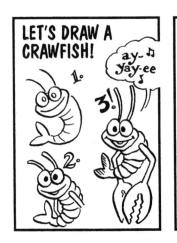

Practice Here

MUDPIE IS ROCKETING THROUGH SPACE. CONNECT THE STARS TO SEE WHAT CONSTELLATION HE IS NEAR!

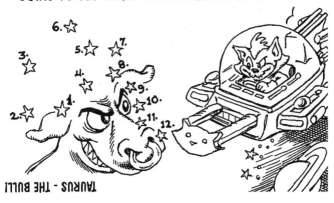

TAURUS - THE BULL!

WHAT GOES WITH WHAT? DRAW A LINE FROM THE PICTURE ON THE LEFT TO THE PICTURE ON THE RIGHT THAT BELONGS WITH IT!

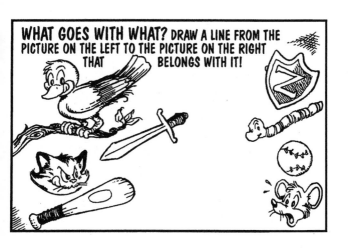

Practice Here

WHICH
TWO
KIDS

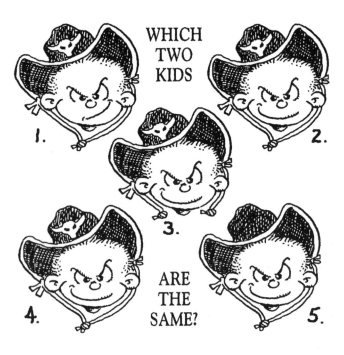

1.

2.

3.

ARE
THE
SAME?

4.

5.

Kids two and four are the same

MUDPIE™

AAH!! MY WALLS! WHAT DO YOU CALL *THIS?*

"SURREALISTIC GENIUS IN CRAYON"

I'LL BET SALVADOR DALI'S MOM DIDN'T MAKE *HIM* GO SIT IN THE CORNER!

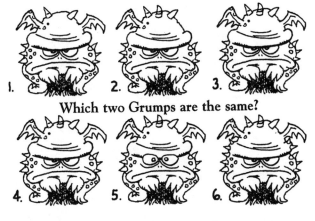

Which two Grumps are the same?

Grumps three and four are the same!

GUY'S GENIUS CLUB

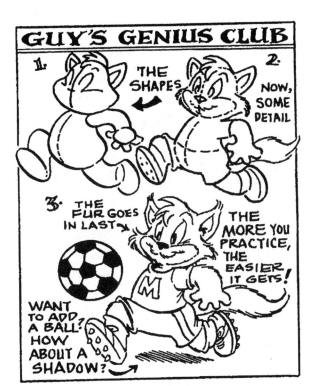

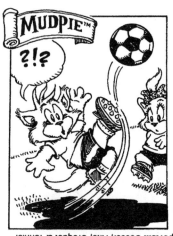

Which Two... #2 & #4! Spring Sports... Soccer, Kite, Croquet & Tennis!

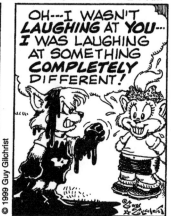

© 1999 Guy Gilchrist

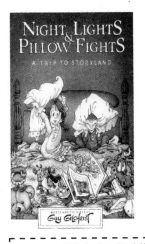

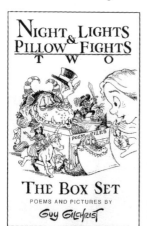

Night Lights & Pillow Fights books
available from Gilchrist Publishing

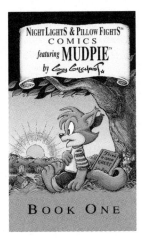

**Night Lights & Pillow Fights
Comics featuring Mudpie
Book One**

-by Guy Gilchrist

If you've enjoyed this book, you'll want to order our other exciting and fun Night Lights collections! If you order now for a very limited time, Guy Gilchrist will autograph your copy and send it to you! And there's more - See next page for *another* Gilchrist book.